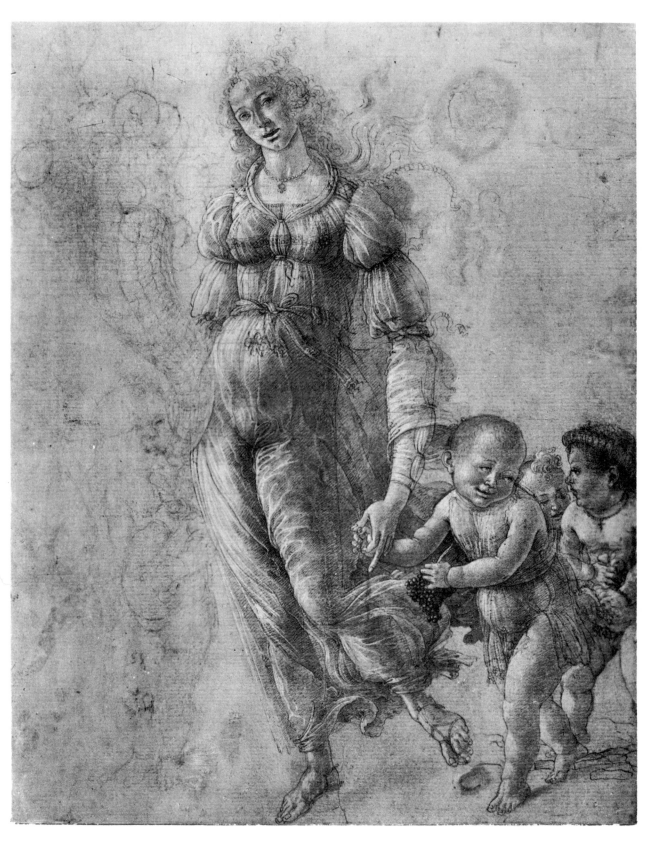

Abundance. Black crayon, pen, watercolor, white lead highlights, on rose-colored prepared paper. 31.7 x 25.3 cm. British Museum, London.

BOTTICELLI
DRAWINGS

44 Works by Sandro Botticelli

DOVER PUBLICATIONS, INC.
NEW YORK

Publisher's Note

The fame of Sandro Botticelli (Alessandro di Mariano di Vanni Filipepi; 1445–1510) rests principally on his paintings, especially those milestones of the Italian Renaissance, the *Primavera* and *Birth of Venus*. If his drawings do not share the same universal renown, it is because their number is so limited, especially when one discounts works of dubious attribution. Bernhard Berenson suggests that few have survived because the apprentices in Botticelli's studio used the drawings again and again in executing paintings.

The majority of the Botticelli drawings that have come down to us is comprised in the 92 illustrations for Dante's *Divine Comedy*, executed sometime between 1490 and 1500 on a commission from Lorenzo (Lorenzino) de' Medici. (The artist had tackled the subject previously; an edition of the poem published in 1481 contained 19 Botticelli drawings, clumsily engraved by Baccio Bandi, which were tipped into the *Inferno*.) Three of the drawings in the series Lorenzino commissioned are colored, indicating that such may have been the intention for the whole work. The others, however, preserve the master's line. Drawn with a metal stylus on white vellum sheets measuring approximately 32 x 42 cm each, they were inked over to varying degrees. In many cases the stylus line has faded almost completely. At their best, these illustrations allow us to study Botticelli's incomparable contour lines, so filled with energy, rhythm and grace. Of the drawings Berenson says, "Here he is free as nowhere else, and here, therefore, we see him in his most unadulterated form. The value then of these illustrations consists of their being the most spontaneous product of the greatest master of the single line which our modern Western world has yet possessed."

Copyright © 1982 by Dover Publications, Inc.
All rights reserved under Pan American and International Copyright Conventions.

Published in Canada by General Publishing Company, Ltd., 30 Lesmill Road, Don Mills, Toronto, Ontario.
Published in the United Kingdom by Constable and Company, Ltd., 10 Orange Street, London WC2H 7EG.

Botticelli Drawings is a new work, first published by Dover Publications, Inc., in 1982.

Manufactured in the United States of America
Dover Publications, Inc.
180 Varick Street
New York, N.Y. 10014

Library of Congress Cataloging in Publication Data

Botticelli, Sandro, 1444 or 5-1410. Botticelli drawings. (Dover art library) I. Botticelli, Sandro, 1444 or 5-1510. I. Title. II. Series.
NC257.B68A4 1982 741.945 81-17356 ISBN 0-486-24248-X (pbk.) AACR2

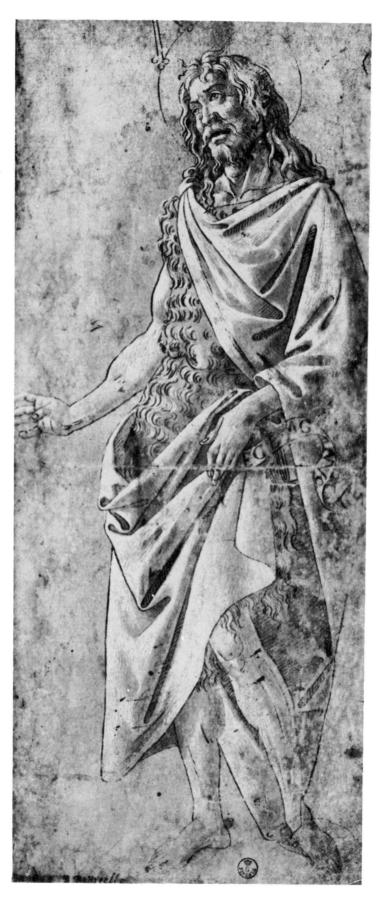

St. John the Baptist. Watercolor and white lead on rose-colored prepared paper. 36 x
15.5 cm. Uffizi Gallery, Florence.

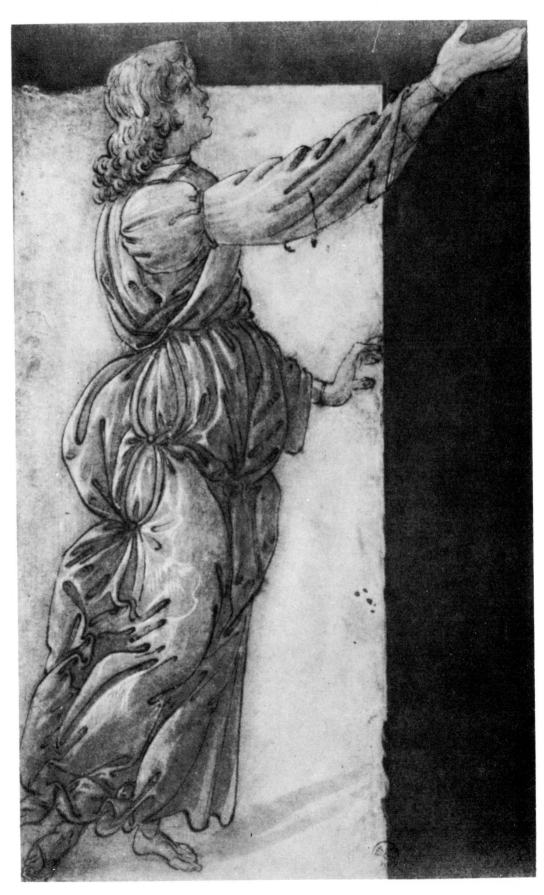

Angel. Pen, watercolor and white lead highlights. 27 x 18 cm. Uffizi Gallery, Florence.

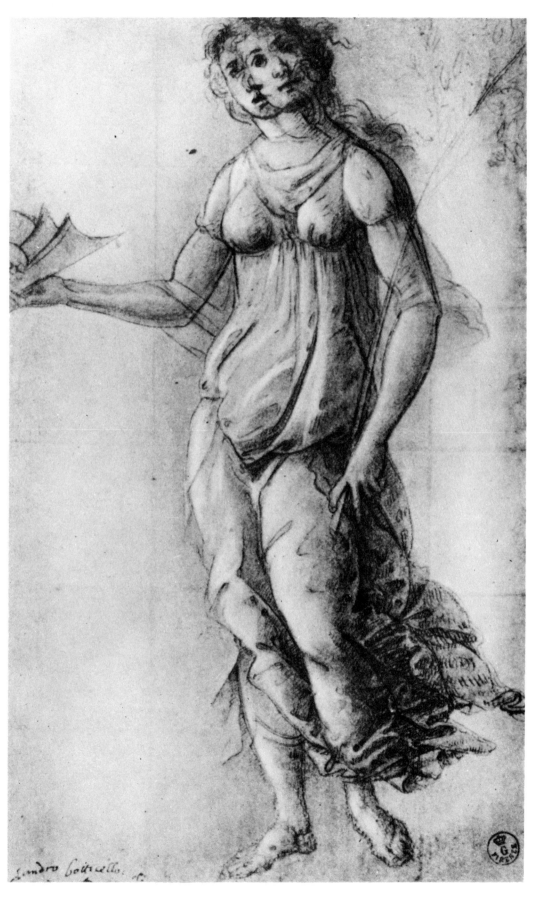

Pallas. Black crayon and pen with white lead highlights on rose-colored prepared paper.
22 x 14 cm. Uffizi Gallery, Florence.

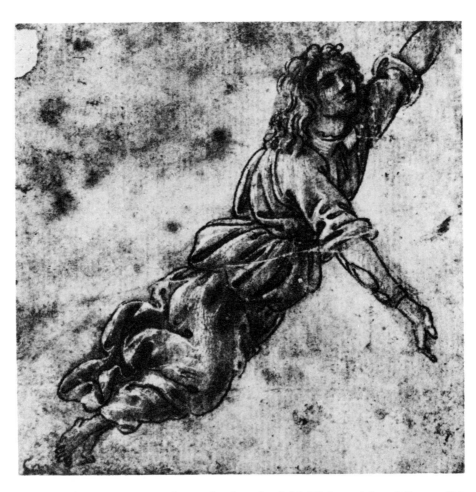

Angel in Flight. Pen, watercolor and white lead highlights. 9.2 x 9.5 cm. Private collection, Bologna.

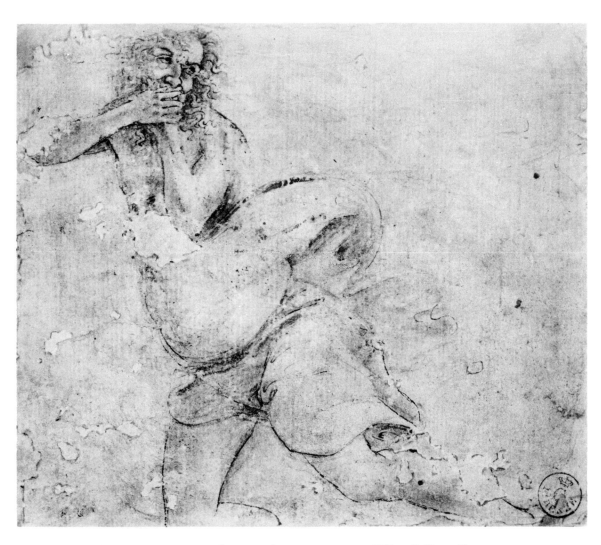

Fleeing Figure. Pen and watercolor. 13.5 x 16 cm. Uffizi Gallery, Florence.

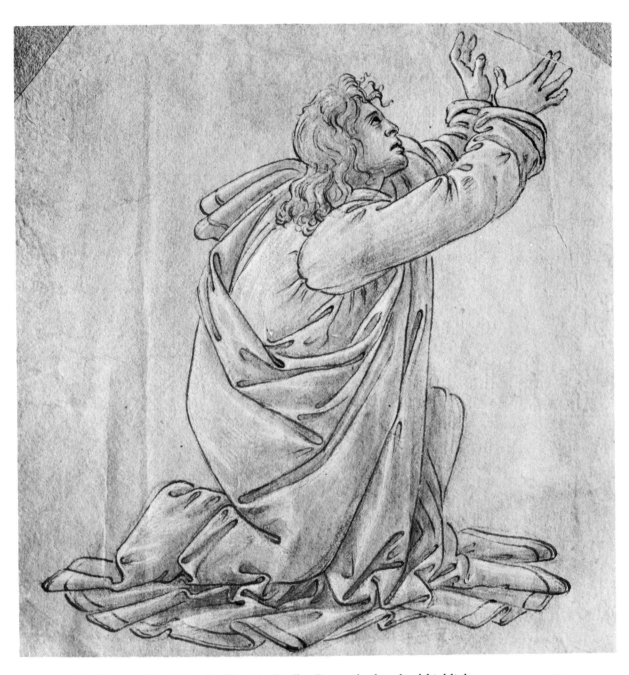

St. Thomas Receiving the Virgin's Girdle. Pen and white lead highlights over a crayon sketch on tinted paper. 17.5 x 12 cm. Biblioteca Ambrosiana, Milan.

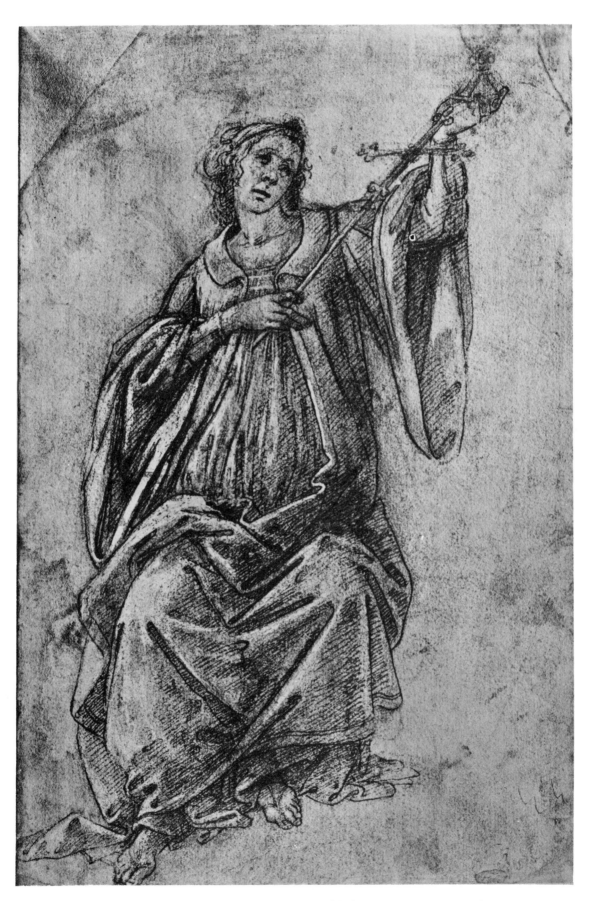

Faith. Pen over a sketch in black crayon; white highlights. 25 x 16.6 cm. British Museum, London.

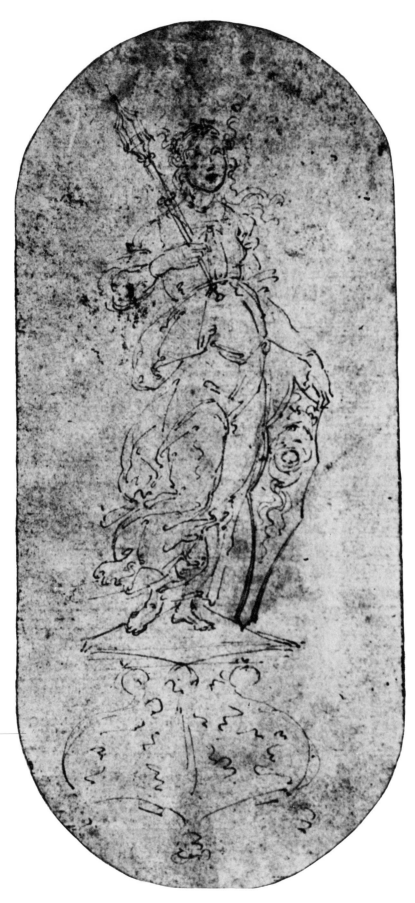

Pallas. Pen. 19 x 6.6 cm. Biblioteca Ambrosiana, Milan.

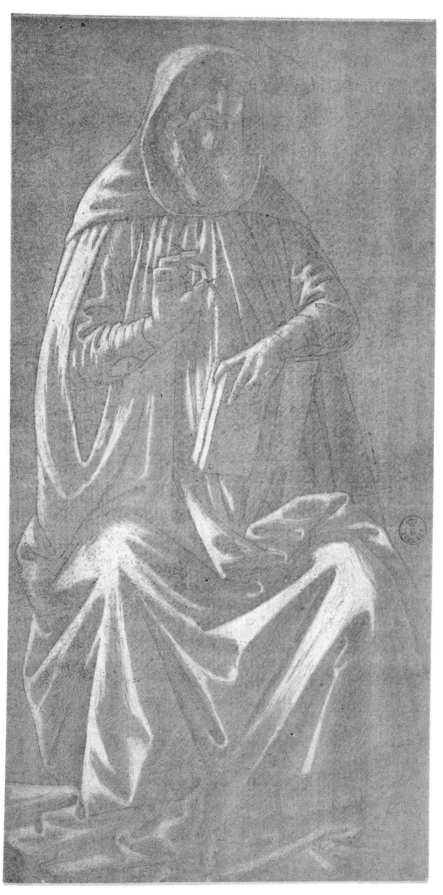

St. Jerome. Uffizi Gallery, Florence.

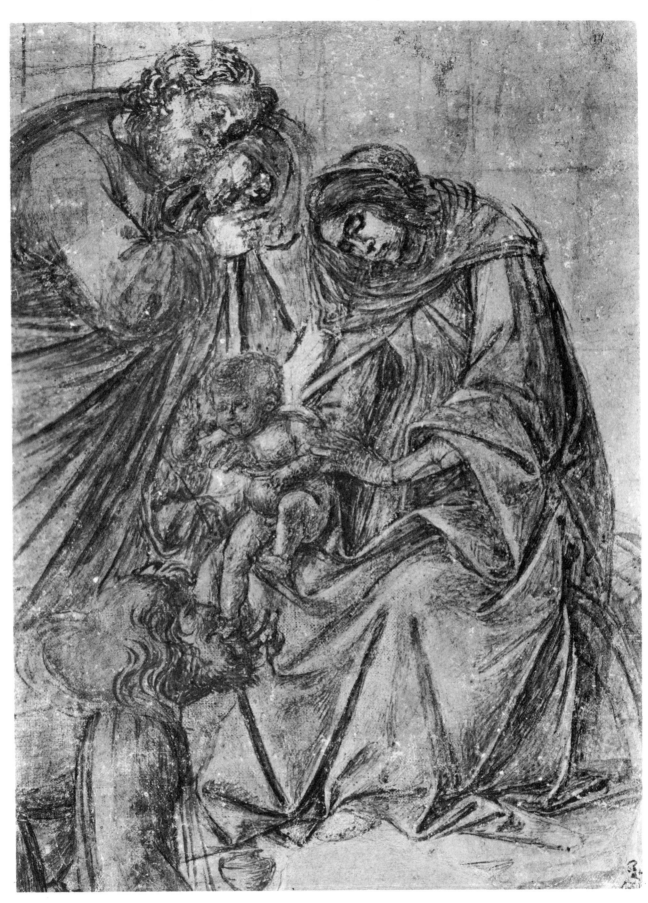

Adoration of the Magi (fragment of central portion). Chiaroscuro in tempera on canvas.
30 x 23 cm. Fitzwilliam Museum, Cambridge.

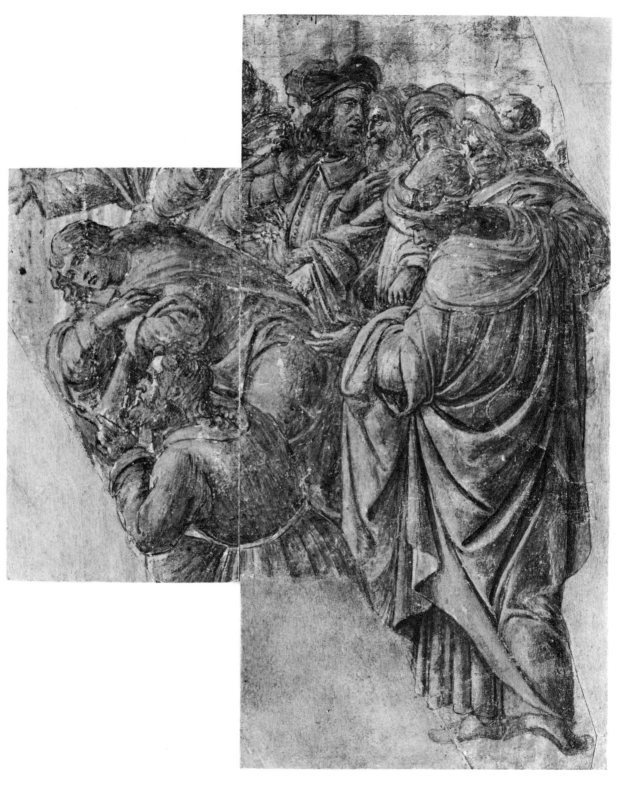

Adoration of the Magi (fragment of right side). Chiaroscuro in tempera on canvas. 44 x 37 cm. Fitzwilliam Museum, Cambridge.

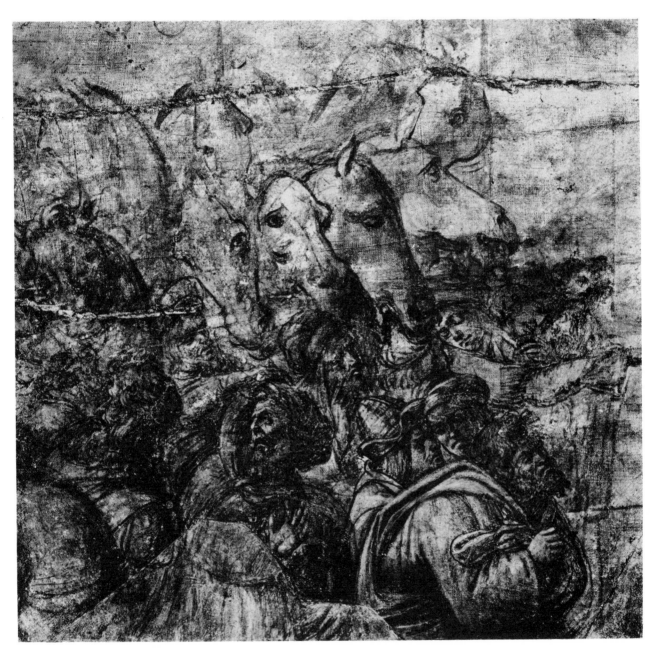

Adoration of the Magi (fragment of the left side). Chiaroscuro in tempera on canvas. 17.5 x 19.5 cm. Morgan Library, New York.

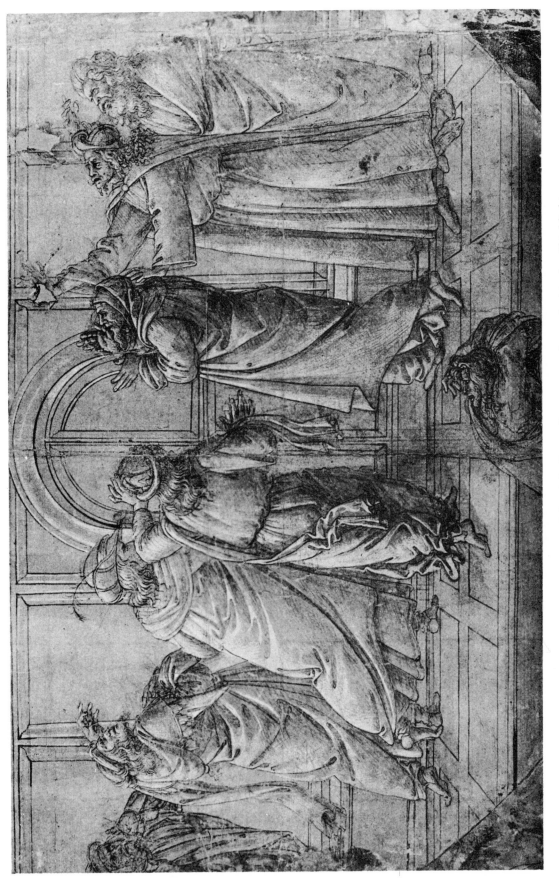

The Infidels and the Descent of the Holy Spirit. Pen, watercolor and white lead highlights. Kupferstichkabinett, Darmstadt.

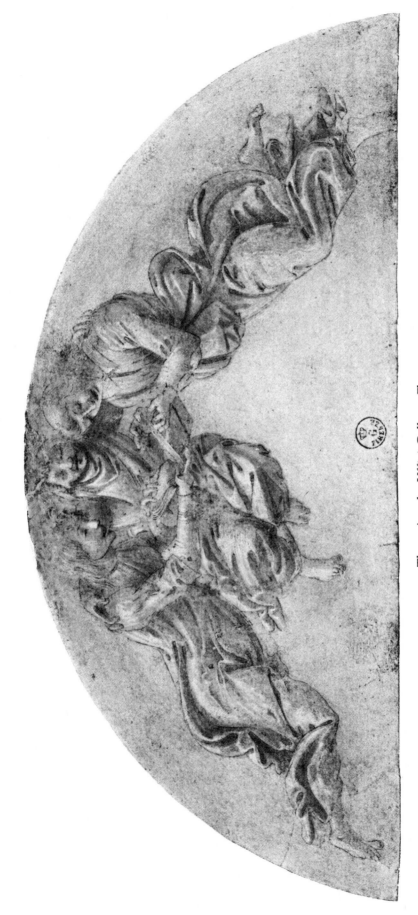

Three Angels. Uffizi Gallery, Florence.

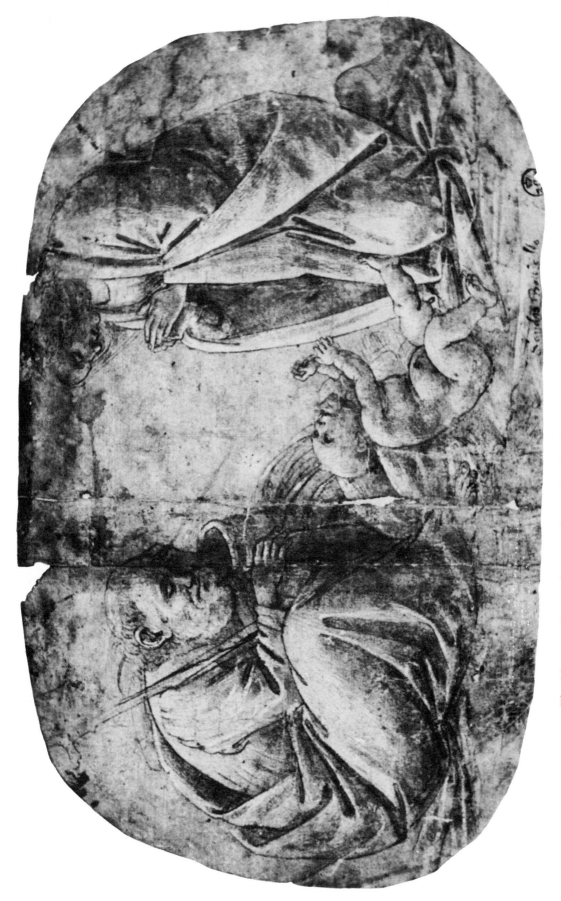

The Nativity. Pen and watercolor with white lead highlights, on rose-colored prepared paper. 16 x 26 cm. Uffizi Gallery, Florence.

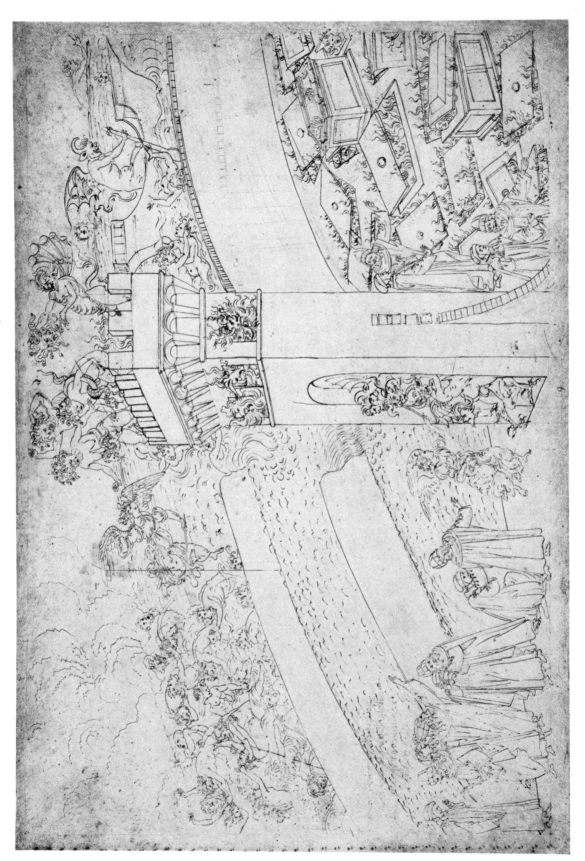

Inferno, IX: The portals of Dis and the heretics. Biblioteca Apostolica Vaticana, Vatican City. (For the dimensions and media of this and the following illustrations for *The Divine Comedy*, see Publisher's Note.)

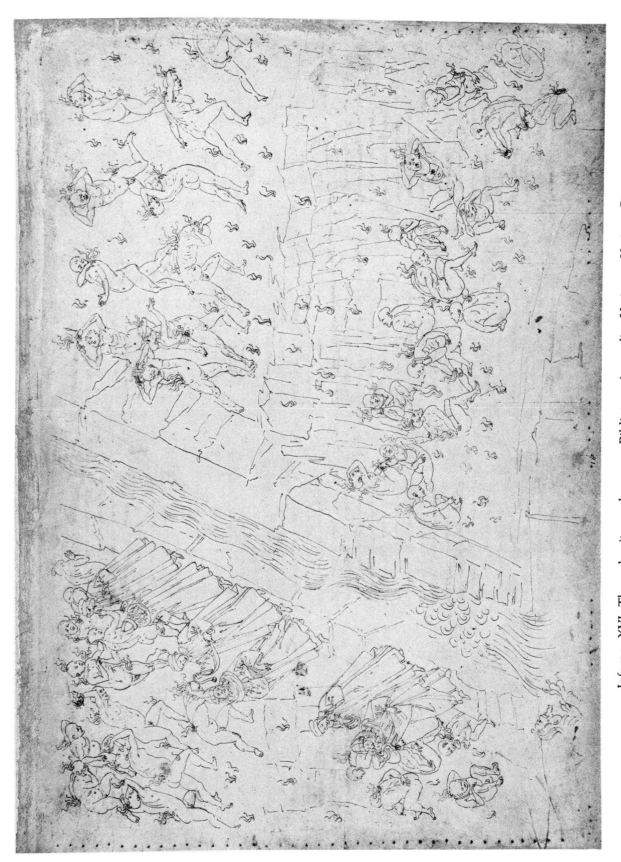

Inferno, XVI: The sodomites and usurers. Biblioteca Apostolica Vaticana, Vatican City.

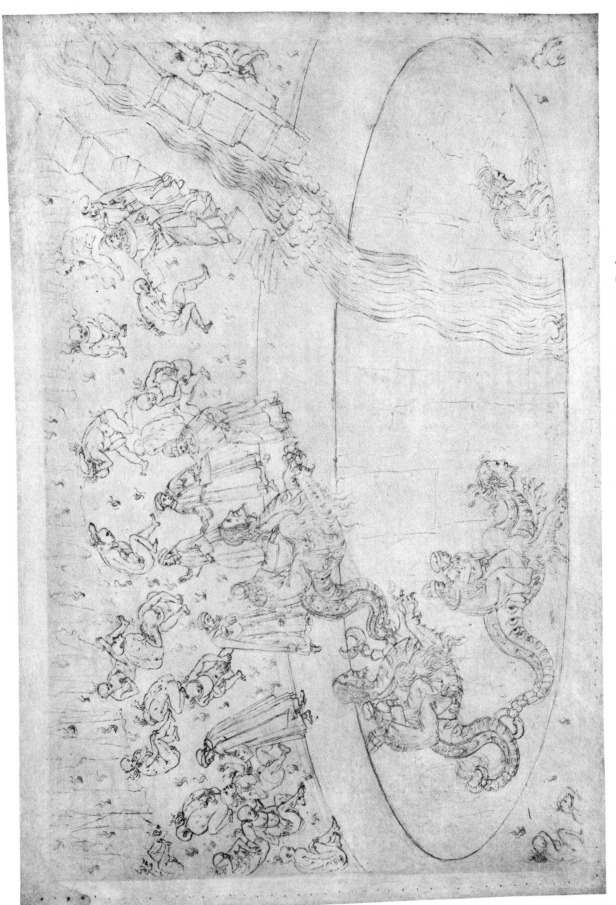

Inferno, XVII: The descent on Geryon. Kupferstichkabinett, West Berlin.

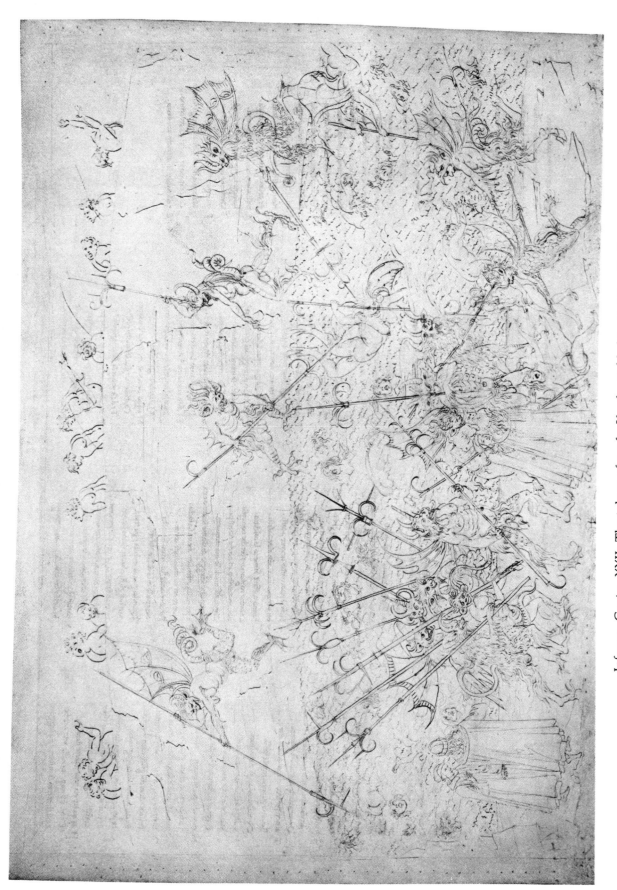

Inferno, Canto, XXII: The takers of graft. Kupferstichkabinett, West Berlin.

Inferno, XXVII: The evil counsellors. Kupferstichkabinett, West Berlin.

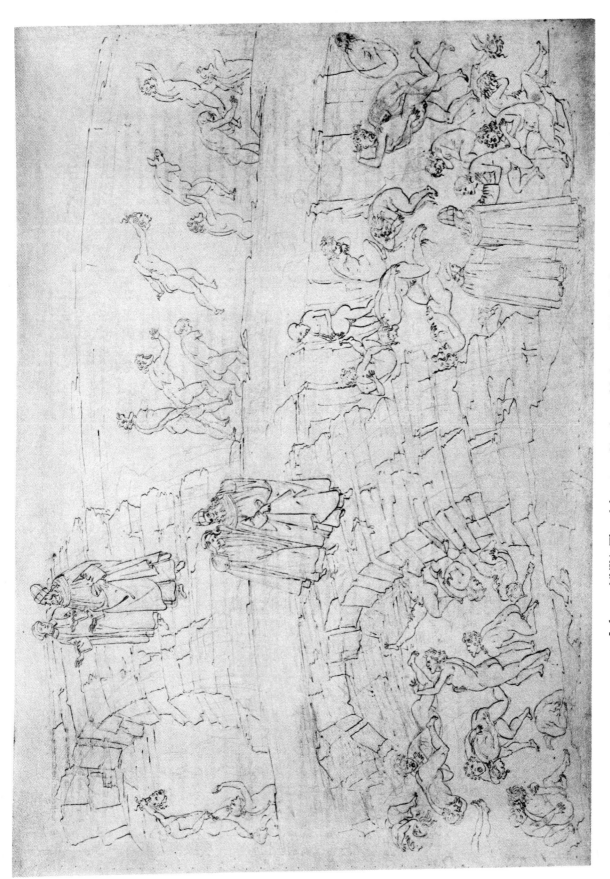

Inferno, XXIX: The alchemists. Kupferstichkabinett, West Berlin.

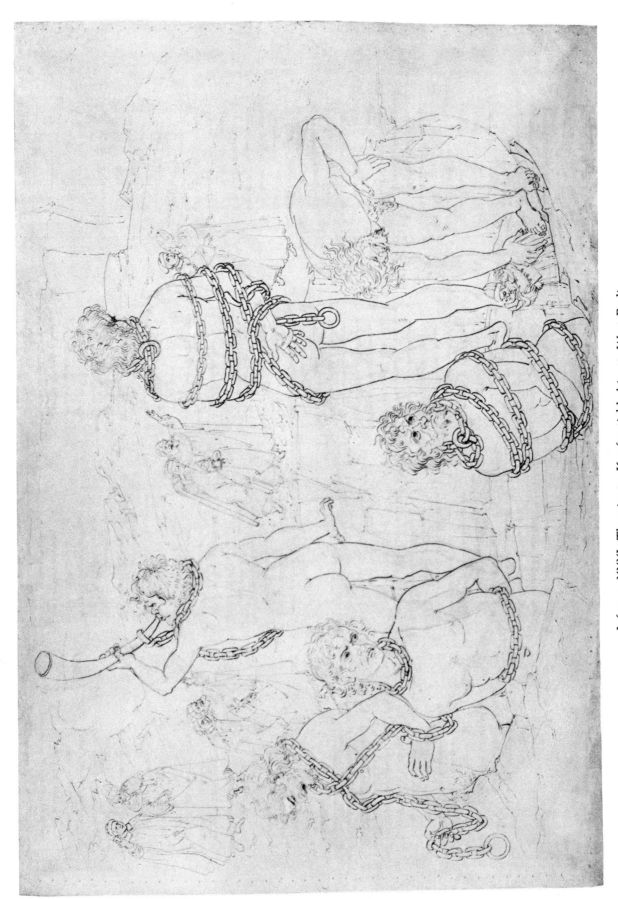

Inferno, XXXI: The giants. Kupferstichkabinett, West Berlin.

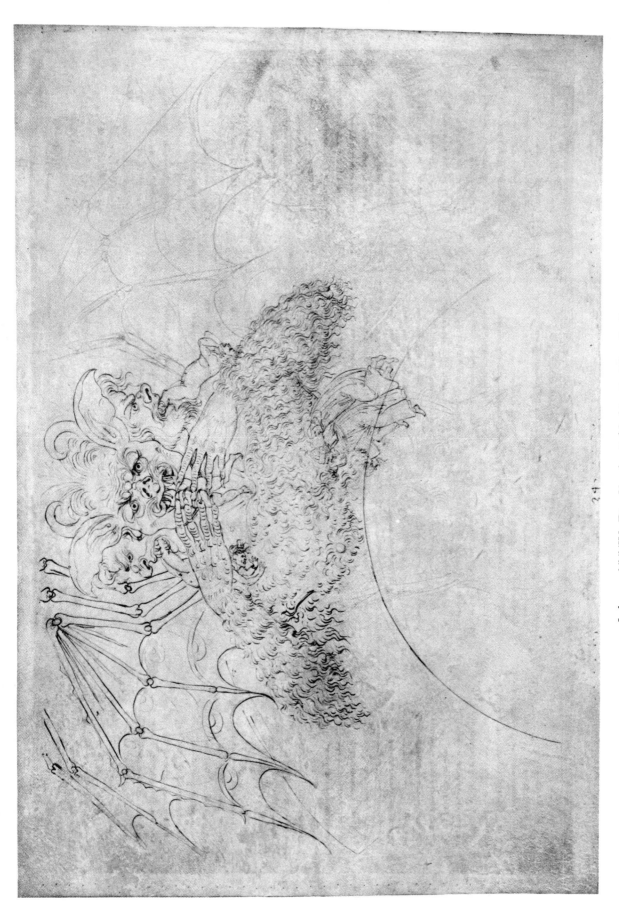

Inferno, XXXIV: Dis. Kupferstichkabinett, West Berlin.

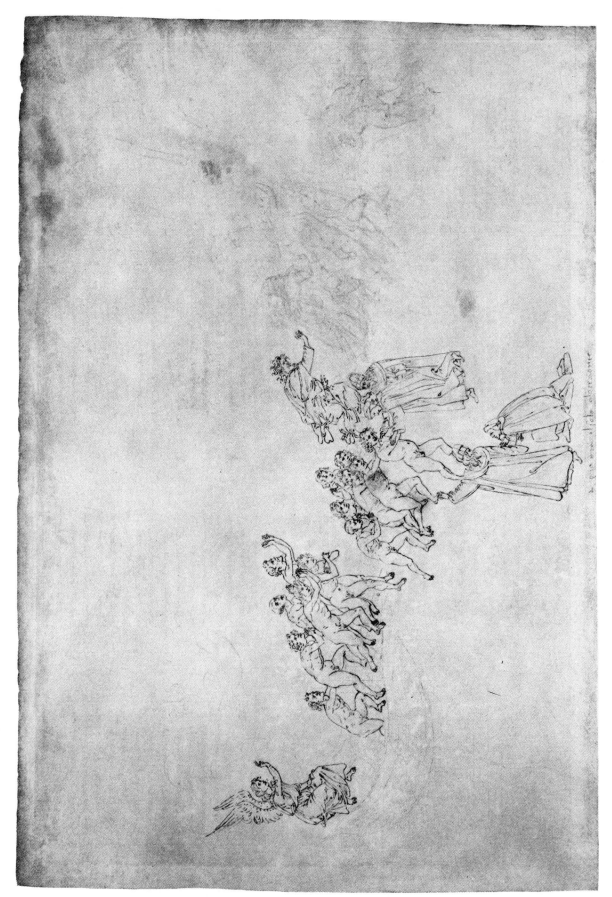

Purgatorio, II: The celestial pilot. Kupferstichkabinett, West Berlin.

Purgatorio, III: The foot of the mountain. Kupferstichkabinett, West Berlin.

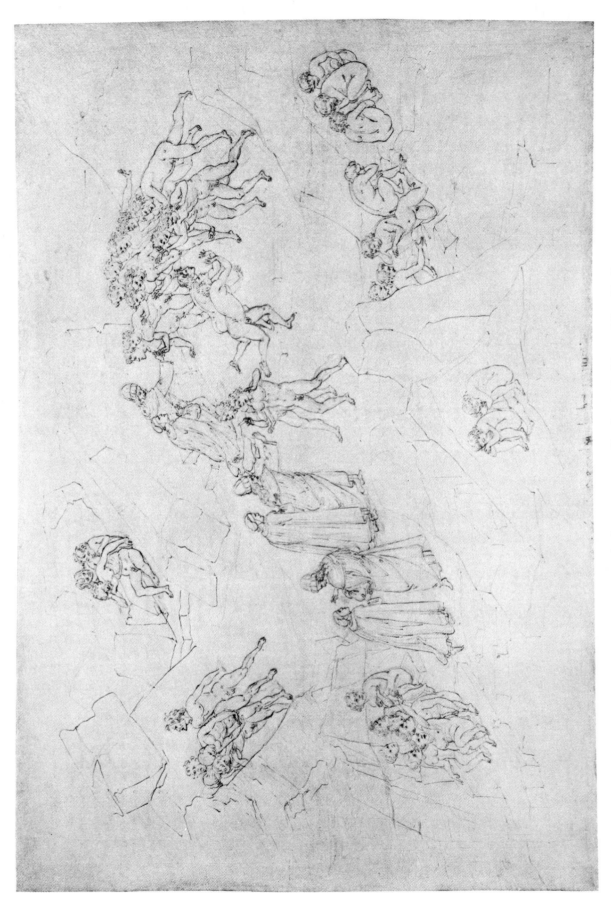

Purgatorio, V: The late-repenters. Kupferstichkabinett, West Berlin.

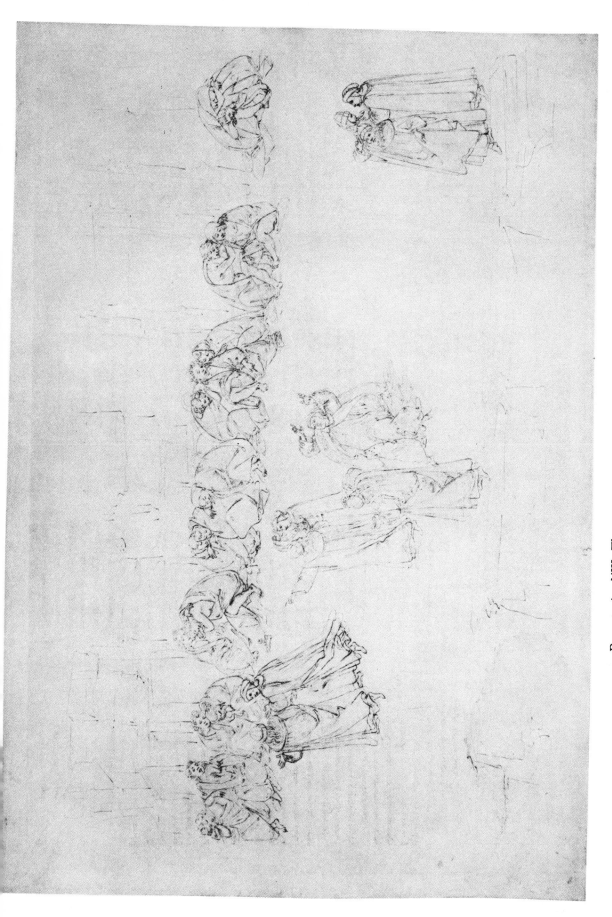

Purgatorio, XIII: The envious. Kupferstichkabinett, East Berlin.

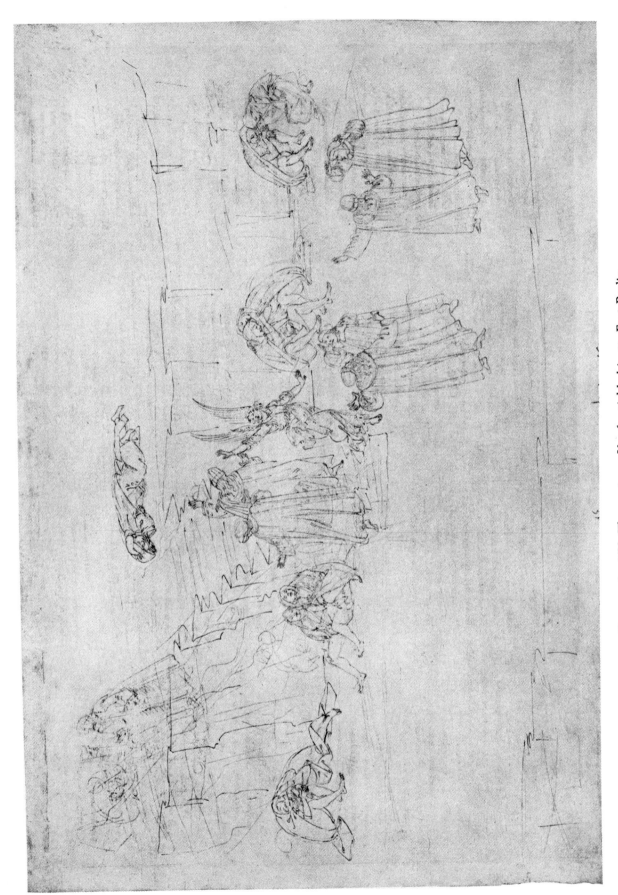

Purgatorio, XV: The envious. Kupferstichkabinett, East Berlin.

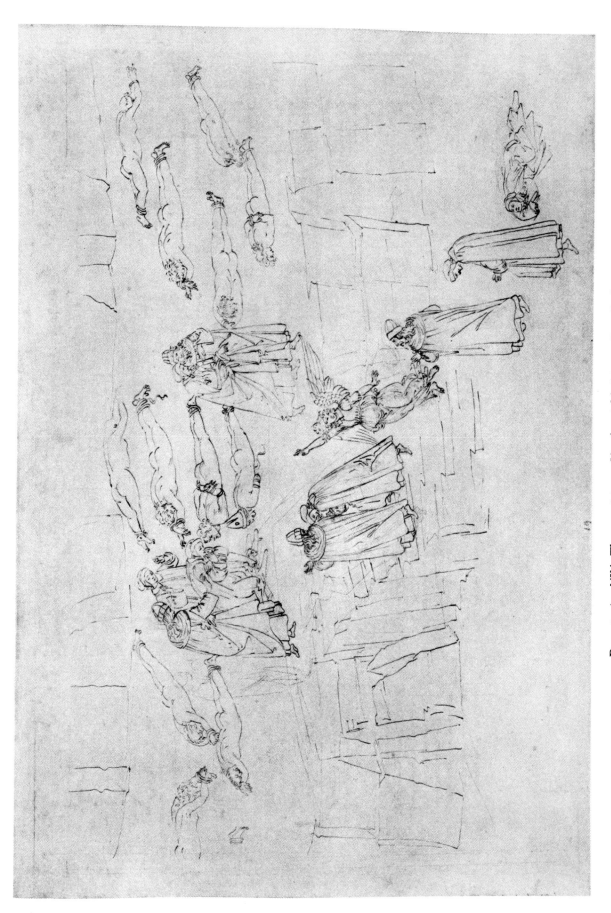

Purgatorio, XIX: The avaricious. Kupferstichkabinett, East Berlin.

Purgatorio, XXVIII: Terrestrial paradise. Kupferstichkabinett, East Berlin.

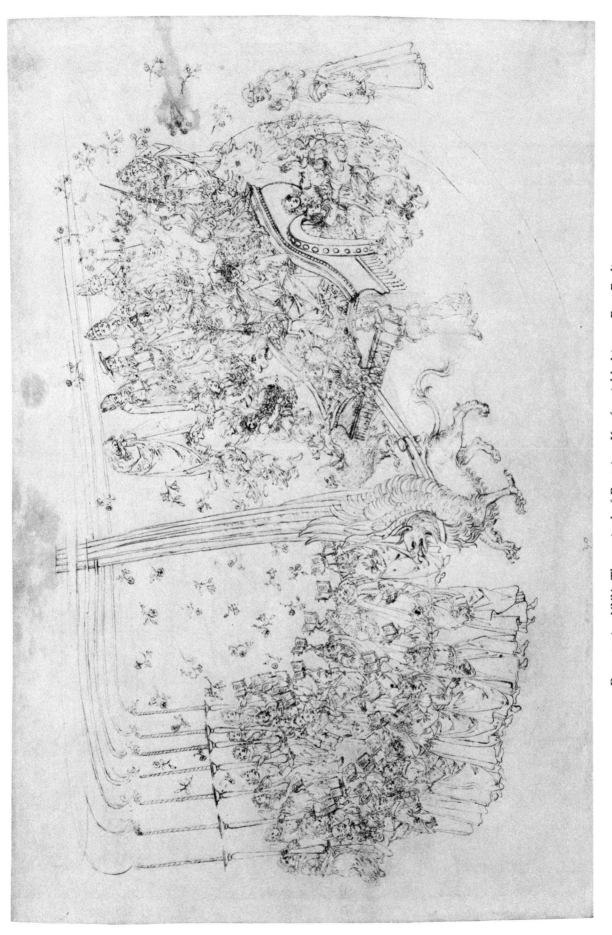

Purgatorio, XXX: The arrival of Beatrice. Kupferstichkabinett, East Berlin.

Purgatorio, XXXI: Beatrice. Kupferstichkabinett, East Berlin.

Purgatorio, XXXII: The mystic pageant. Kupferstichkabinett, East Berlin.

Paradiso, I: Beatrice and Dante ascend. Kupferstichkabinett, East Berlin.

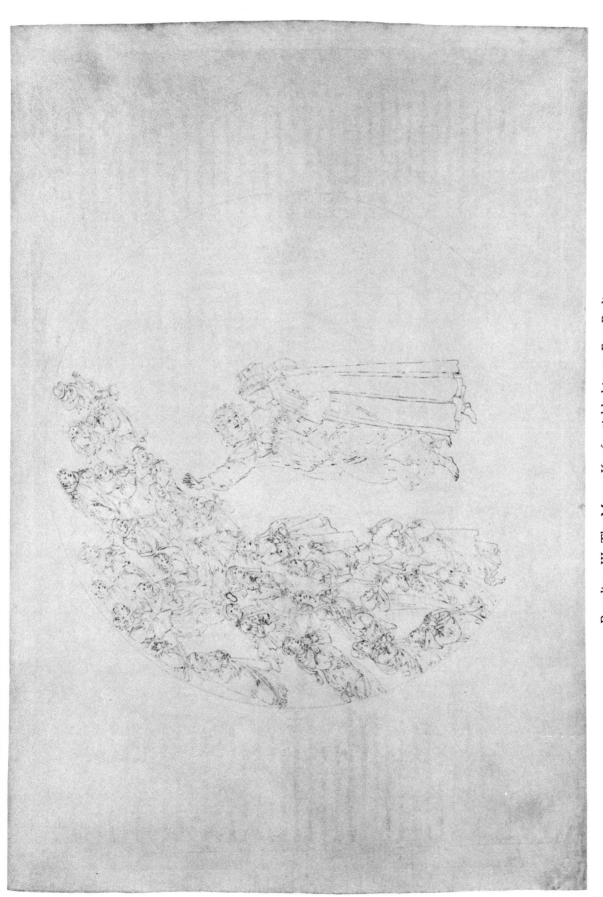

Paradiso, III: The Moon. Kupferstichkabinett, East Berlin.

Paradiso, IV: The Moon. Kupferstichkabinett, East Berlin.

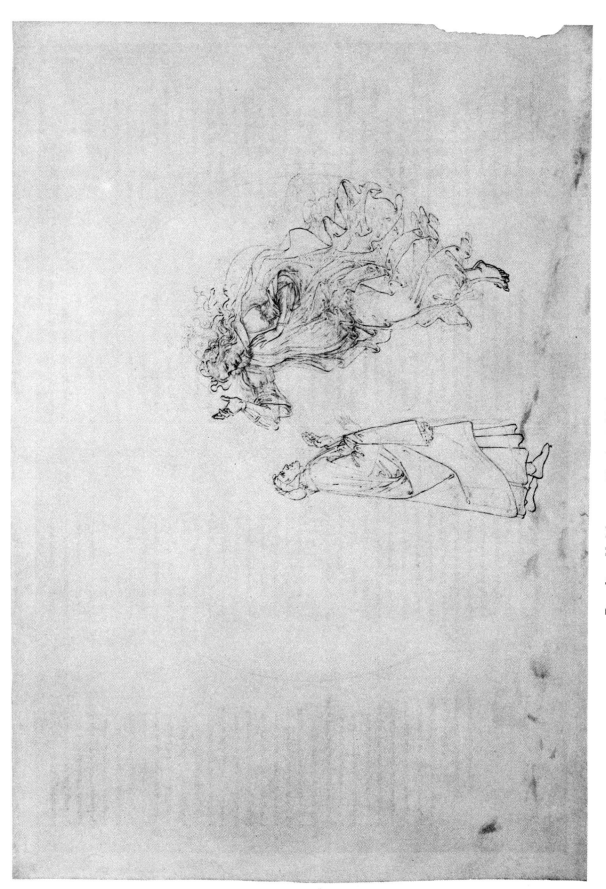

Paradiso, V: Mercury. Kupferstichkabinett, East Berlin.

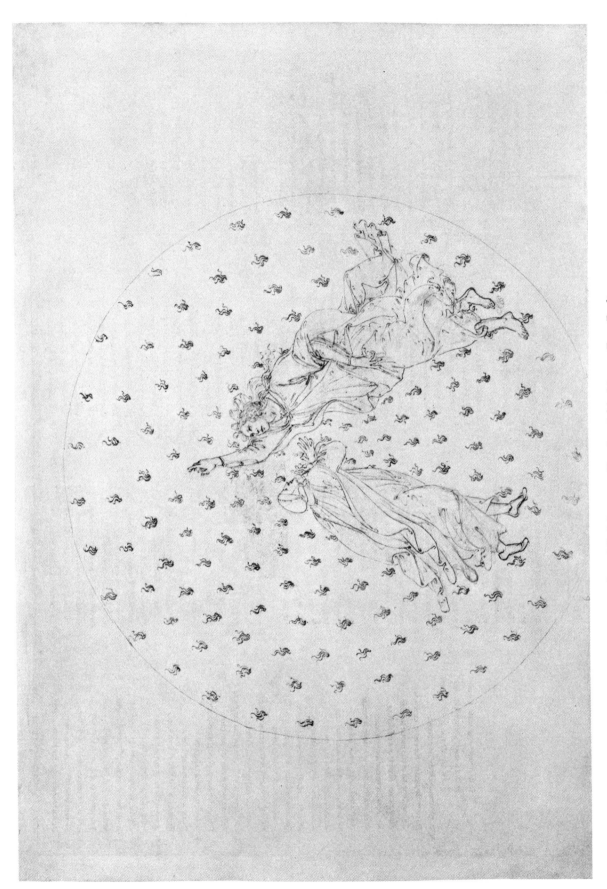

Paradiso, VI: Mercury. Kupferstichkabinett, East Berlin.

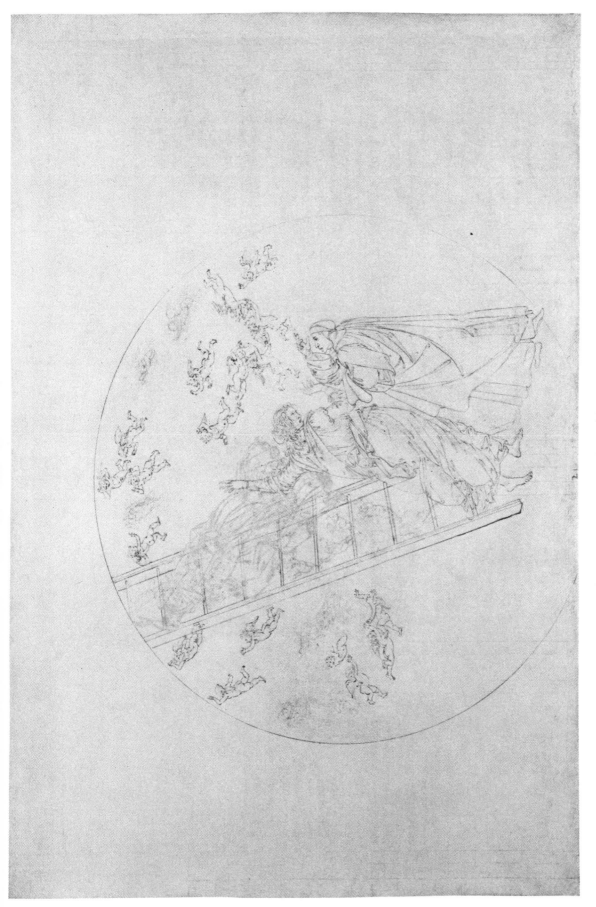

Paradiso, XXI: Saturn. Kupferstichkabinett, East Berlin.

Paradiso, XXII: Saturn. Kupferstichkabinett, East Berlin.

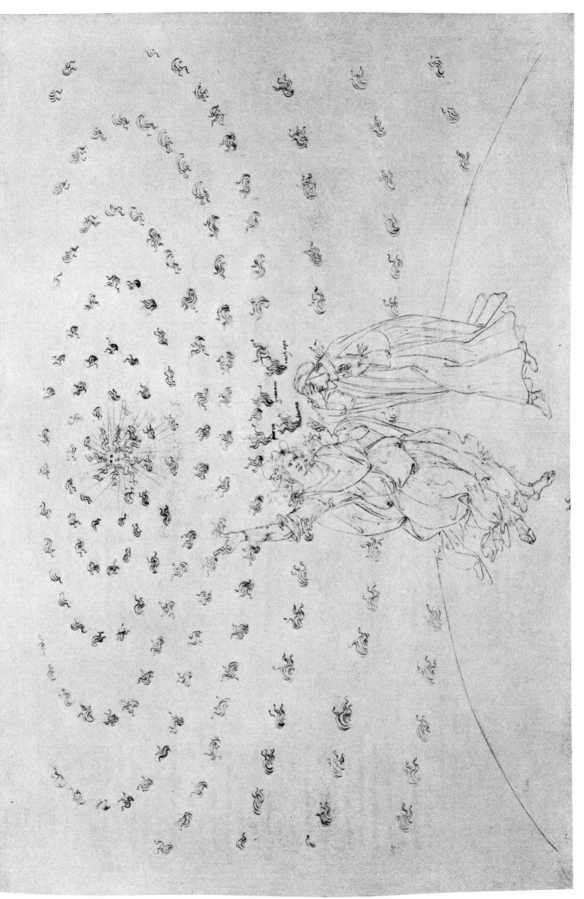

Paradiso, XXVI: The fixed stars. Kupferstichkabinett, East Berlin.

Paradiso, XXVII: The fixed stars. Kupferstichkabinett, East Berlin.

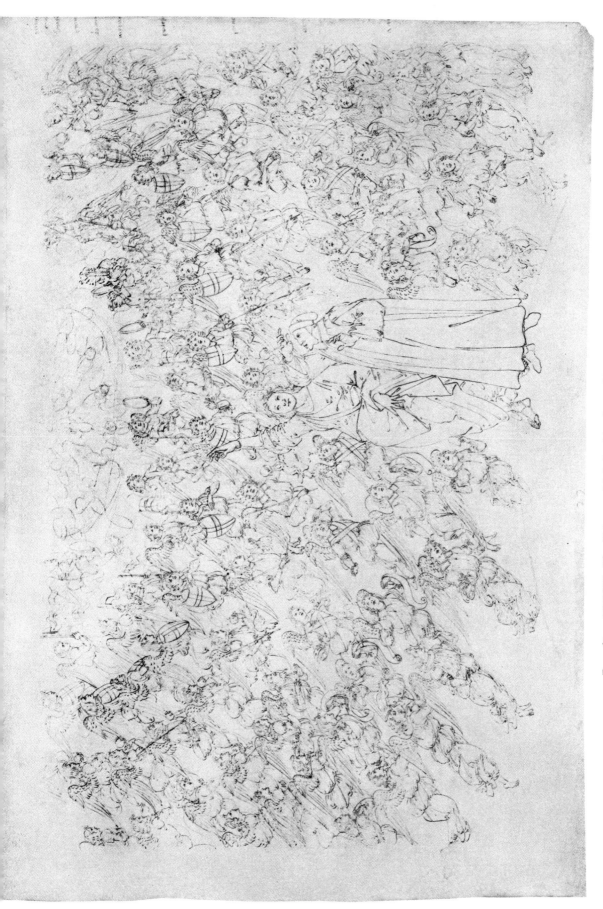

Paradiso, XXVIII: The Primum Mobile. Kupferstichkabinett, East Berlin.